Austin's playfulness in both art and commerce is captured in Jim Franklin's 1972 advertisement for Inner Sanctum Records. (Author's collection/ Jim Franklin.)

ON THE COVER: The Stallion Drive-In Restaurant, with its traditional Southern menu, stood at 5602 North Lamar Boulevard from its opening in 1948 until its closing in 1984. This 1950 view shows the original building, which was expanded several times. (Austin History Center ND-50-235-01.)

IMAGES of America
LOST AUSTIN

John H. Slate

Copyright © 2012 by John H. Slate
ISBN 978-0-7385-9613-6

Published by Arcadia Publishing
Charleston, South Carolina

Printed in the United States of America

Library of Congress Control Number: 2012941489

For all general information, please contact Arcadia Publishing:
Telephone 843-853-2070
Fax 843-853-0044
E-mail sales@arcadiapublishing.com
For customer service and orders:
Toll-Free 1-888-313-2665

Visit us on the Internet at www.arcadiapublishing.com

To the denizens of Old Austin and the preservers of Austin's history.

Contents

Acknowledgments 6

Introduction 7

1. Lost Landmarks, Neighborhoods, and Homes 9
2. Lost Austin Institutions 43
3. Lost Food, Drink, and Fun 73
4. Lost Austin Businesses 103
5. Endangered Austin 123

Acknowledgments

To the following visionaries, individuals, and entities, I offer my sincere thanks and appreciation: Michael Miller, Daniel Alonzo, and the staff of the Austin History Center (AHC); Chad Seiders; Dana and Darin Tetens; KMFA; Rosemary Moore; Nicki Turman; David C. Fox; the *Austin American-Statesman*; Scott Sayers; Jenna McEachern; Ken Hoge; David Fox; the Austin Vacuum Cleaner Company; Scott Conn; Aina Dodge; Carlos Lowry; Gerald Swick; Thorne Dreyer/*The Rag*; Alan Pogue; Matt's El Rancho; Kerry Awn; Joe Bryson; Bob Simmons; Sasha Sessums and the Sessums family; Jim Franklin/JFKLN; Leea Mechling and the South Austin Popular Culture Center; Eddie Wilson/Threadgill's; Mariann Wizard; Micael Priest; Mark Dean; Flip Kromer; Michael Lucas; Texas Archive of the Moving Image; Bratten Thomason; Gene Fowler; John Wheat; Texas Historical Commission; and the Dolph Briscoe Center for American History. Special thanks go to my wife, Lucinda.

Unless otherwise noted, all images are from the following collections of the Austin History Center, Austin Public Library: Austin American-Statesman Negative Collection, Austin History Center Photograph Collection, Chalberg Collection of Prints and Negatives, General Collection, Neal Douglass Photograph Collection, Hubert Jones Glass Plate Colletion.

INTRODUCTION

Austin is the capital of the state of Texas and the seat of Travis County. Located in central Texas on the eastern edge of the Llano Estacado ("staked plains"), it is the fourth-largest city in Texas and the fifteenth-largest in the United States. Composed of a diverse mix of university professors, students, politicians, musicians, state employees, and high-tech, blue-collar, and white-collar workers, the city is also home to the main campus of the University of Texas and several other universities. In spite of its impressive institutions, Austin was a relatively quiet, slow-paced city until its emergence as a major international entertainment destination and a business powerhouse during the 1980s and beyond.

As Austin has grown more cosmopolitan, remnants of its small-town history have faded away. Austin's uniqueness—found in its past as much as it exists today—was reflected in its food, architecture, historic places, music, citizens, and businesses. Many of these beloved people and places have moved on into history. While some have disappeared into the mists of time, others are more recent and still generate fond memories of good times and vivid experiences.

This book can barely begin to tell the rich history behind the variety and history of vanished Austin restaurants, historic buildings, nightclubs, landmarks, and public art, but it's a start. Were it not limited by space, this book would have included dozens of other places with storied pasts, including countless historic structures; businesses such as Marshall's Hobby Shop, Kiddie City, the Nineteenth Hole Liquor, and The Cadeau; restaurants like Morty's Pizza King, Lung's, and Su Casa; and clubs such as The Checkered Flag, The One Knite, Castle Creek, Duke's Royal Coach Inn, Mother Earth, Moyer's Cue Club, Hook 'Em, Sit-N-Bull, the Sco-Pro Lounge, and the Orange Bull Arcade ("Good BS is our Specialty").

With only a few exceptions, everything in this book is gone from Austin's landscape. But their memories linger on in writing, in photography and moving images, in music, and in our hearts and minds. The real joy of this book is found in the uncountable number of stories that will be ignited by its images.

A vision of Austin's laid-back past is well represented in Doug Sahm's 1974 album *Groovers Paradise*. Kerry Awn's intricate black-and-white ink album art includes symbols of Austin, such as armadillos, Tex-Mex food, the governor's mansion, a taco stand, musicians, Oat Willie's, and flowering plants of all kinds. Presiding over it all is a jukebox sunset with "Sir" Doug looking on. (Kerry Awn.)

One
Lost Landmarks, Neighborhoods, and Homes

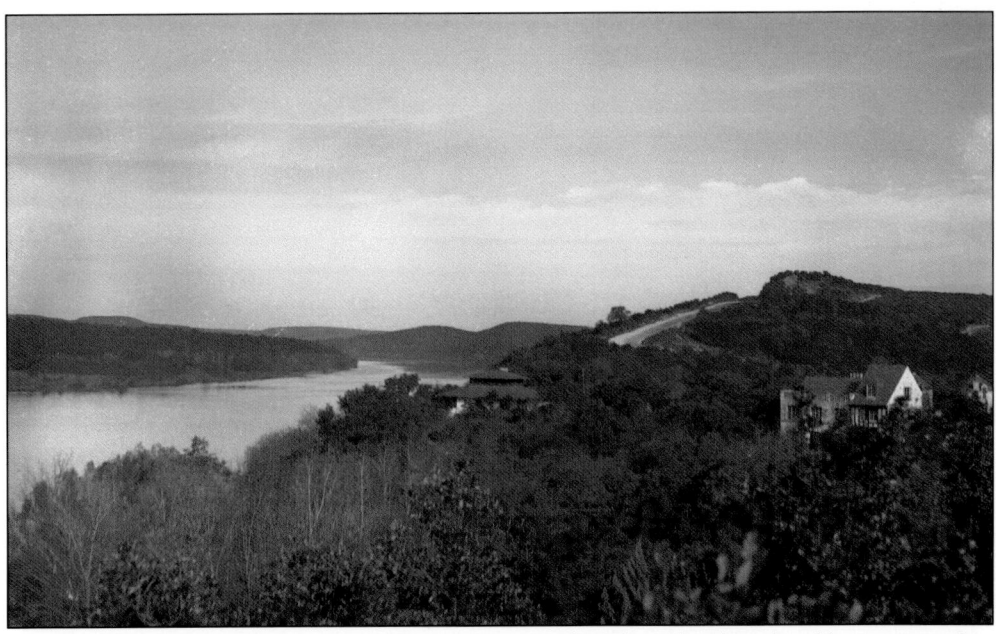

Until the late 1950s and early 1960s, West Austin was largely undeveloped and houses were few. Since this 1943 photograph was taken of Mount Bonnell Road and Lake Austin, from what is now the Austin Museum of Art–Laguna Gloria, the area has changed dramatically. Many homeowners today are working to maintain the native habitat that includes wildflowers and the ubiquitous cedar (Ashe juniper). (AHC ND-43-121-06.)

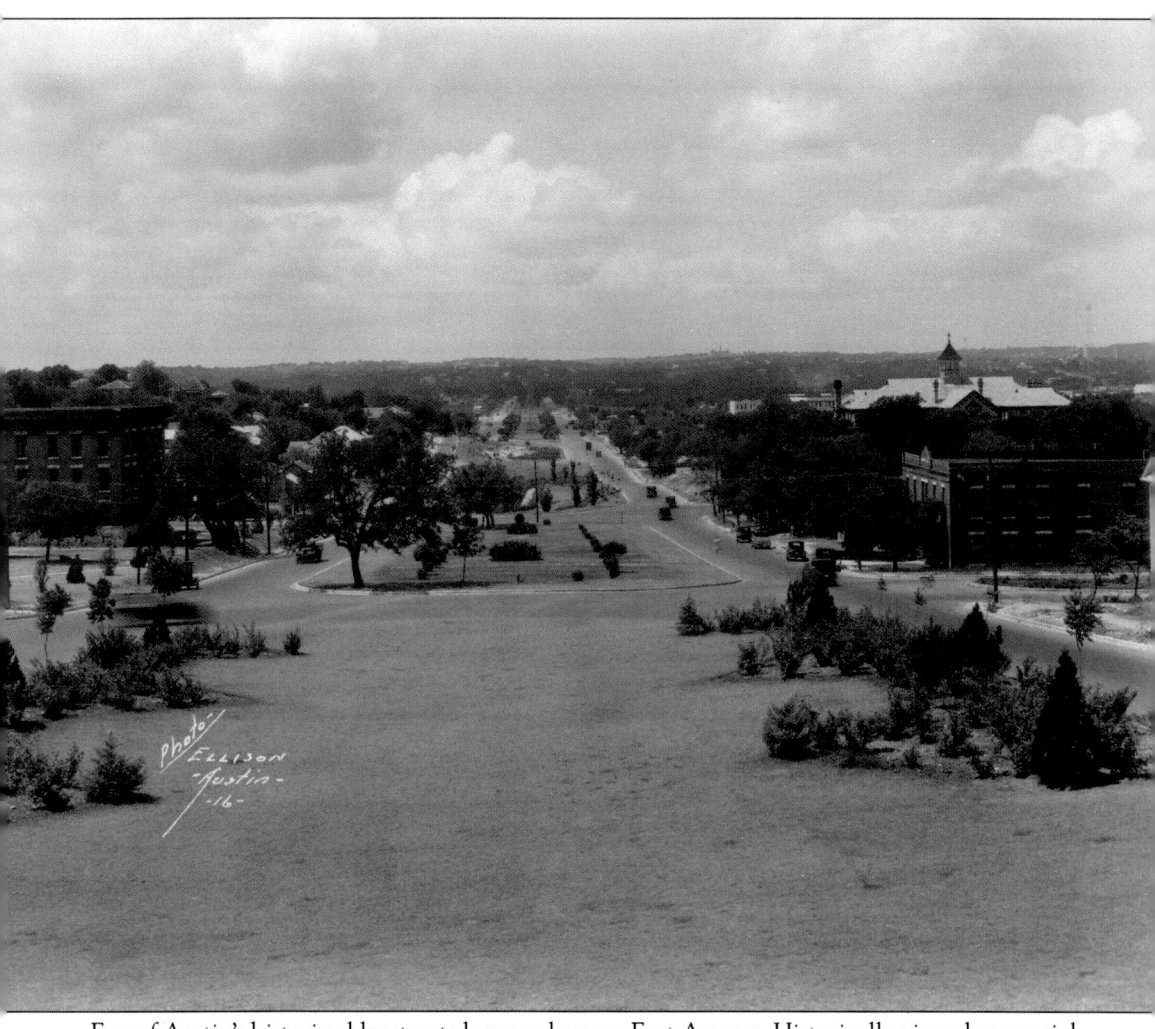

Few of Austin's historic older streets loom as large as East Avenue. Historically viewed as a racial and ethnic dividing line, pieces of East Avenue still exist, but most is underneath US Interstate 35, completed in 1960. This elevated view of a newly paved East Avenue looks south from the stone lookout platform at Twelfth Street, with Bickler Academy (building with cupola) to the right at Eleventh Street. (AHC C02070.)

Edwin Waller, the first mayor of Austin, designed Congress Avenue to be the city's most prominent street. Congress retains many of its landmarks, such as the Paramount and State Theaters, but many businesses have come and gone. The above photograph, looking north toward the capitol, shows the Congress Avenue Bridge in 1950. In the below image, from about 1949, changes in the landscape already appear; trolleys that ran up and down the street for decades ended in 1940. (Above, AHC ND-50-348-02; below, AHC PICA02507-a.)

Travis County's courthouse from 1855 to 1875 had been small and simple, but the new courthouse that opened in 1876 was monumental, elegant, and ornate. A three-story limestone building erected for $100,000 by Burt McDonald from plans drawn by Jacob Larmour and Charles Wheelock, it was Austin's best example of Second Empire architecture. Complete with ironwork cresting, decorative dormers, and mansard roofs, the courthouse stood on the southeast corner of Eleventh Street and Congress Avenue, directly across from the Texas State Capitol. By 1927, the distinctive cupolas had disintegrated and were removed. It was remodeled as the Walton Building and used as offices for state agencies before it was demolished in 1964. Since then, the site has been used as a parking lot. (Above, AHC PICA 25216; below, AHC PICA 01093.)

Austin's city hall from 1871 to 1906 stood on the northeast corner of Eighth and Colorado Streets, where the Republic of Texas capitol had been located. A two-story stone building with a clock tower, it housed Austin's first fire station and an opera house. When the building was just a few years old, a large population of bats moved in, and the structure was nicknamed "the rookery." (AHC PICH 00429.)

Complete with a cupola, Austin's second passenger railway station was built for the International–Great Northern Railroad in 1888 on the southwest corner of West Third Street and Congress Avenue. Built by Gustav Wilke, the primary contractor for the state capitol, its Romanesque features were obliterated when it was remodeled in Art Deco style in the 1920s. The station was razed in 1955, and a high-rise apartment complex now stands there. (AHC AFF-P6150(51).)

This distinctive building, called the Shot Tower, was built in 1866 by William Alexander and was purportedly used for the production of lead shot ammunition. The warehouse at its rear was the first home of radio station KVET, started by a group of local World War II veterans that included John Connally and Jake Pickle. The unique structure at 113 West Eighth Street was demolished in 1974. (AHC PICH 05023.)

Travis County had a most unusual jail in Austin from 1876 to 1932 that resembled a castle, including two turrets. The stone jail was a temporary home to outlaws John Wesley Hardin, Johnny Ringo, and later the embezzler-turned-writer William Sydney Porter, better known as O. Henry. Quickly outgrown, the building was razed to make room for the Dewitt C. Greer State Highway Building. (AHC C00610.)

Bounded by today's Twenty-fourth, Twenty-sixth, Leon, and San Gabriel Streets, the freedmen's community of Wheatville was founded after the Civil War. The area was first settled in 1869 by James Wheat, a freed slave. Overtaken and absorbed by Austin, Wheatville was surrounded by white neighborhoods in the 1920s, and black families were pushed to East Austin through city planning. The only remaining structure of Wheatville is the Franzetti Building, located at 2402 San Gabriel. Rev. Jacob Fontaine lived here from 1877 until his death in 1898. In this building, Fontaine also conducted church services, operated a grocery and laundry, and published the *Gold Dollar* newspaper, the first black newspaper in Austin. The Franzetti family operated a grocery store in the building from 1916 to the 1960s. (Author's collection.)

The St. Johns Community, located in what is now north Austin, was established by the St. Johns Regular Missionary Baptist Association, a group of African American churches that built the St. John's Industrial Institute and Orphanage in 1907. The orphanage was located on what is now Airport Boulevard near Highland Mall. It was destroyed by fire but was rebuilt in 1911. The orphanage provided domestic and elementary instruction through the early 1940s, then ministerial and missionary training into the 1950s. It was destroyed by fire again in 1956. The City of Austin annexed the St. Johns Community in 1951. Above, attendees are pictured at an annual encampment. (Above, AHC PICA 04421; below, AHC PICA 17164.)

The Union Bus Depot, located at 118 East Tenth Street, adjacent to the Travis County Courthouse, was built in 1930 in a Moderne style that was used for many depots across the country. As the name suggests, Austin's bus station served several companies, including Greyhound, Continental Trailways, and Kerrville Bus Company. The above photograph shows the station as it appeared about 1938. The below image shows a busy interior from about 1951. (Above, AHC PICH 06788; below, AHC C06408.)

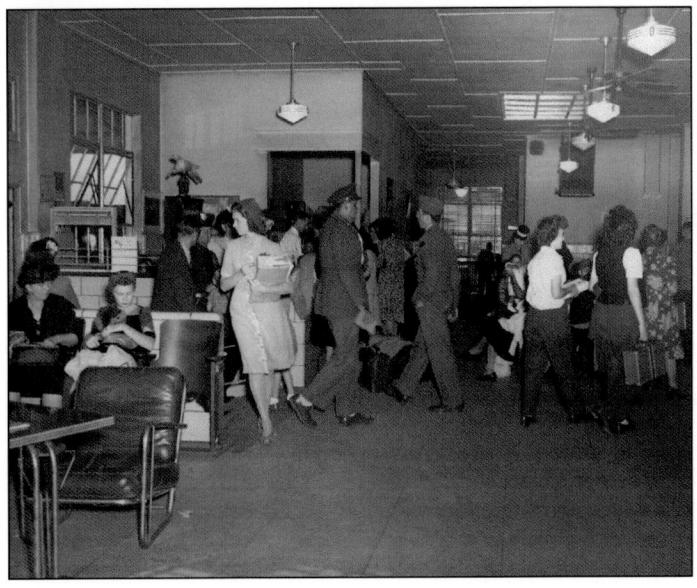

Austin-Bergstrom International Airport served as Bergstrom Air Force Base from 1942 to 1993, when it was closed and refurbished, through a City of Austin bond program, into a municipal airport. It was originally Del Valle Airfield, but was renamed Bergstrom in 1943 for Capt. John August Earl Bergstrom, the first Austinite killed in World War II. During its lifetime as a base, it was home to multiple troop carrier groups; a Strategic Air Command unit; and numerous fighter, bombardment, and tactical reconnaissance wings. During the Vietnam War, the base served as the home of the Twelfth Air Force. Above, several men and a woman lift an engine from a C-47 airplane. Below, pilots from the 12th Tactical Reconnaissance Squadron, in Bergstrom tradition, toast their safe return from a mission in 1971. (Above, AHC ND-43–118-02; below, AHC PICA 11704.)

Now the site of the Long Center complex, Lester Palmer Auditorium opened in 1959 as the Municipal Auditorium and was named in honor of Lester Palmer, an Austin city council member in the 1950s who later served as mayor of Austin from 1961 to 1967. Its familiar patchwork dome graced Riverside Drive for over 40 years, finally giving way to the R. and Teresa Lozano Long Center for the Performing Arts. It played host to countless Austin Symphony performances, trade conventions, and national and international musical acts from every genre. At right, the dome's ribs are being fitted into place in 1959. Below is the building as it appeared in the 1980s. (Right, AHC PICA 26486; below, AHC PICA 14333.)

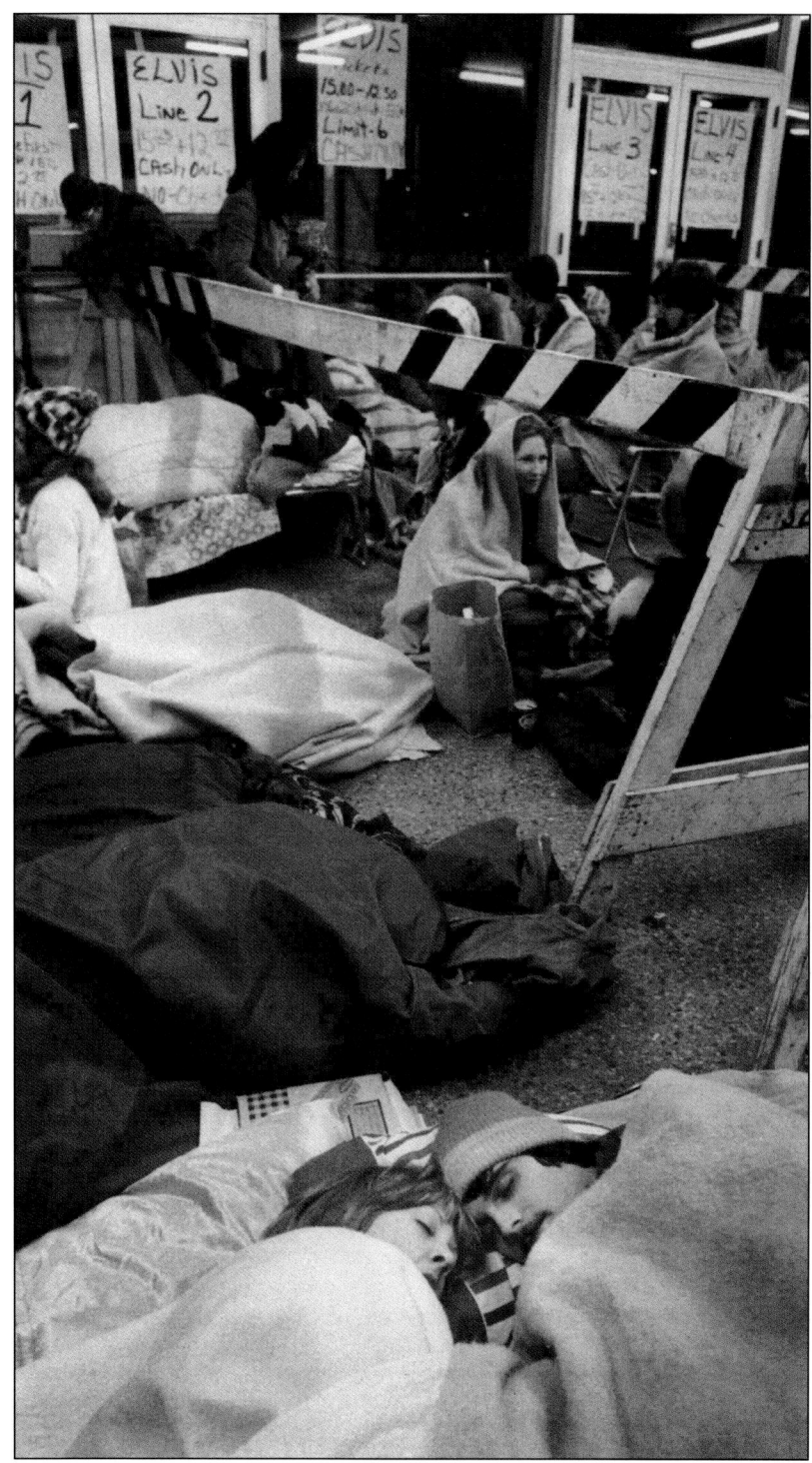
Palmer Auditorium was an important stop for most major touring acts before other large-capacity venues opened in the area. In this image, Elvis Presley fans brave the cold for tickets to his show at the auditorium on March 28, 1977, only five months before his death. (AHC PICA 11531.)

Robert Mueller Municipal Airport, Austin's first city-operated airport, opened in 1930. Named in honor of a city commissioner who died in office, it served the Austin area for nearly 70 years until it closed in 1999 and was replaced by Austin Bergstrom International Airport. The 711-acre site was modernized in 1961 when a new control tower and terminal built for the jet age was dedicated by Vice Pres. Lyndon B. Johnson. Its iconic control tower, with alternating light blue and dark blue porcelain panels, was designed by the Austin architectural firm Fehr and Granger. After it closed, the land was redeveloped to become the planned urban development Mueller Community. At right, Lyndon Johnson speaks at the rededication in May 1961. The photograph above shows a Braniff Douglas DC-2 awaiting passengers in 1938. (Above, AHC PICA 15898; right, AHC PICA 03771.)

Private and public education has served the Austin community since its founding, but many of its early structures are no longer standing. In the c. 1918 photograph above, proud students pose in front of the Sisters of the Holy Cross Parochial School of Our Lady of Guadalupe Church, located at 1112 East Ninth Street. Below is St. Mary's Academy in an undated postcard. The girls' school, which still exists today, was built in 1885 between East Seventh and East Eighth Streets at San Jacinto Street. The structure, built of Travis County limestone, was used for over 60 years before it closed in 1947. (Above, AHC PICA 25921; below, AHC AFF-P6150(31).)

The second Austin High School, built in 1900 and designed by Burt McDonald and James Reilly, was a domed, ornate, redbrick building nicknamed "Old Red." The structure was at the corner of 400 East Fourth Street and thrived under the supervision of principal James E. Pearce and superintendent A.N. McCallum. By 1925, enrollment outgrew the building, and it served as Allan Junior High until it was destroyed by fire in 1956. It is now the site of the third location of the First Baptist Church. Above is the building as it appeared during its prime. Below is an undated scene of the woodworking shop. (Above, AHC PICA 18727; below, AHC PICA 07516.)

The third Austin High, which still stands at 1212 Rio Grande Street, is now a part of Austin Community College. Above is a photograph of the literary club's 1943 spring dance. Below is a photograph of the high school's nearby classic student hangout, the Maroon Mill, located at 816 Rio Grande. By the early 1970s, the Mill became a rougher place. (Above, AHC PICA 23006; below, AHC Annuals Collection.)

University Junior High, abbreviated to UJH, was the middle school located on the University of Texas campus at San Jacinto and Martin Luther King Boulevards. The university and the independent school district funded its construction, and it served as a school from 1933 to 1967, when it was converted to offices. It now houses the UT School of Social Work. A historical landmark, the school is a yellow brick Spanish Renaissance structure with sturdy wings and connecting arcades. Many notable Austinites attended here, including Dallas Cowboy Thomas Henderson, broadcaster Verne Lundquist, and Threadgill's entrepreneur Eddie Wilson. (Above, AHC PICA 007603; right, AHC PICA 07610.)

Austin Colored High School, at San Marcos and Eleventh Streets, moved in 1907 to the corner of Olive and Curve Streets and was renamed L.C. Anderson High School, after African American educators E.H. and L.C. Anderson. Anderson moved again in 1913 to 1607 Pennsylvania Avenue, shown here. It closed in 1953 when a new Anderson High was opened at 2601 Thompson Street. (AHC ND-50-A140-02.)

In 1879, Allen Hall, the first building on the campus of Tillotson College (now Huston-Tillotson University), was constructed on land that is now 900 Chicon Street. Designed by Jasper N. Preston, who also designed the Driskill Hotel, Allen Hall was a four-story, Second Empire–style edifice with a mansard roof. It was demolished in 1958. (AHC J139.)

When Judge Edwin Waller planned the city of Austin, he set aside 40 acres of land "most eligible for a University." The University of Texas's Main Building (at right in the photograph) was built in stages from 1882 to 1898, after a design by F.E. Ruffini. The Victorian Gothic landmark was razed in 1934. On the left is the Spanish-Mediterranean Revival Battle Hall, designed in 1909–1910 by Cass Gilbert. (AHC PICA 08510.)

Brackenridge Hall, known as "B Hall," was a men's dormitory built in 1890 that housed generations of student leaders and future greats. Speaker of the House Sam Rayburn and Sen. Ralph Yarborough lived there as students. The building stood where the campus East Mall abuts the Main Mall. The birthplace of "The Eyes of Texas" (the UT school song) and the site of countless student pranks, B Hall was torn down in 1952. (AHC Postcard Collection.)

UT's Chemical Laboratory was the third permanent building on campus, opened in 1892. It was built where the Biology Greenhouse now stands, just north of the Flawn Academic Center. Designed by Burt McDonald, it was a Victorian, two-story, brick building featuring tall, narrow windows and many gables. The 15-room building burned down in 1926, but not before one valiant professor saved the bulk of the department's library. (AHC PICA 20493.)

Clark Field, the university's venerable baseball field, was located at the northwest corner of Red River and Twenty-third Streets and was home to Longhorn baseball from 1927 to 1974. Its chalk hill and centerfield, called Billy Goat Hill, was often a hazard for visiting teams. After the 1974 season, Clark Field was closed to make way for the College of Fine Arts and the Performing Arts Center buildings. (AHC C07758.)

Juarez-Lincoln University was part of the Mexican American education movement in Texas. It opened in 1971 in Fort Worth and later moved to Austin. Originally located at St. Edward's University, it moved to 715 East First Street in 1975. It served about 1,200 students and closed in 1991. Its distinctive mural by Raúl Valdez, shown below, was one of the first in Austin to celebrate Mexican heritage. (Above, AHC PICA 06455; below, Les Simon.)

The Texas Confederate Home opened in 1886 on 16 acres of land at 1600 West Sixth Street. It had a large administration building and living quarters, a hospital, and private cottages. The grounds had a strange network of wires between the main building and the cabins on which blind veterans hooked their walking canes to safely find their way. The administration building was demolished in 1970. (AHC Postcard Collection.)

The Confederate Woman's Home opened in 1908 at 3710 Cedar Street and cared for over 3,400 widows of Confederate soldiers for 55 years. Initially operated by the United Daughters of the Confederacy, it was transferred to the state in 1911. It featured an octagonal tower and castellated parapet; a hospital annex was added later. It closed in 1963, and since 1986 the building has housed Austin Groups for the Elderly. (AHC C00913.)

Built on the site of Tobin Park on Twenty-sixth Street between Nueces and Rio Grande Streets, Seton Infirmary was dedicated by the Daughters of Charity of St. Vincent de Paul on May 29, 1902. The redbrick Georgian Revival building was designed by Rockwell Milligan of St. Louis, Missouri, and contained 17 private rooms, 11 wards, kitchens on each floor, plus separate dormitories and refectories for the sisters. It was demolished in 1975 when the hospital moved to Thirty-eighth Street. (Right, AHC PICA 05272; below, AHC PICA 00217.)

SETON INFIRMARY.

Austin's first public hospital was built in 1884 on Fifteenth Street. This City-County Hospital, the first public hospital in the state, was built of stone and had a mansard roof and steeples reminiscent of Scandinavian architecture. It was replaced by a more modern facility in 1915 and later renamed Brackenridge Hospital, in honor of Dr. Robert J. Brackenridge. Its descendant sits adjacent to the original site. (AHC C00053.)

Holy Cross was Austin's segregated hospital, established by the Congregation of Holy Cross in 1940 with the help of Father Francis Weber of Holy Cross Church. It was located on East Eleventh Street and was replaced with a larger hospital in 1951 on Nineteenth Street, which closed in 1989. Until Austin's hospitals opened fully to people of color, Holy Cross was an important part of black and Mexican American Austin. (AHC ND-50-211-02.)

In 1924, St. David's Episcopal Church approved the sale of bonds to support the Physicians' and Surgeons' Hospital, then located at Seventeenth and Rio Grande Streets, for $75,000. The hospital was owned by Drs. Joe Gilbert, John Thomas, and Sam Key, who were church parishioners. The hospital was chartered as a nonprofit, community-based hospital and was moved from Seventeenth Street to its current location, 919 East Thirty-second Street, in 1955. It is a part of the extensive St. David's Health Care System. (AHC ND-50-107-13.)

First Methodist Church was organized in 1847, and its congregation was originally known as Central Church and Tenth Street Church. This 1883 Gothic Revival structure at Tenth and Brazos Streets was eventually outgrown, and the congregation moved in 1923 to a new building at Lavaca and Twelfth Streets. (AHC C01279.)

Temple Beth Israel was the first synagogue in Austin, built in 1884 through the efforts of early Austin Jews Henry Hirshfeld, Phineas de Cordova, and others. The Classical Revival structure was designed by A.M.C. Nixon from plans drawn by James Wahrenberger and Jacob Larmour. The building was razed in 1957 after the congregation moved to Shoal Creek Boulevard. A hotel now occupies this site at 1101 San Jacinto Street. (AHC ND-49-562-02.)

Organized in 1873 by the Reverend Carl Charnquist, the Swedish Methodist Church built its second sanctuary, a Gothic Revival structure, at West Fourteenth and Colorado Streets in 1898. The fellowship added "Central" to its name and later dropped "Swedish." The church sold its property in 1956 for expansion of state offices. Renamed Memorial Methodist Church, the historic congregation moved to northeast Austin. (AHC C01388.)

Swante Palm (1815–1899), vice consul for Sweden and Norway from 1866 until his death, built this house on Ninth Street in the 1850s. It held Palm's extensive book collection and served as the Swedish consulate, where Palm assisted many Swedish immigrants. He donated his 10,000-volume collection to the University of Texas in 1897, increasing the school's holdings by more than 60 percent. Palm's home was razed in 1958. (AHC PICH 00535.)

Until it was razed in 1923, this Greek Revival structure at 1400 West Avenue was Austin's premier "haunted house" for many years. It was built in the 1850s by Georgetown and Glasscock County namesake George Washington Glasscock Sr., whose wife died of diphtheria there. The bereaved Glasscock presumably left the bad memories behind and lived his remaining days on his farm in Webberville. (AHC PICH 04206.)

This classic Second Empire house at 1914 Nueces was the home of William Lambdin Prather (1848–1905), attorney and president of the University of Texas from 1899 to 1905. His reminder to students that "the eyes of Texas are upon you" gave rise to the university song. The building was demolished in 1969. (AHC PICH 08191.)

The rate at which historic properties are disappearing in East Austin is alarming. The Victorian Gothic structure at 1105 East Twelfth Street was the home of Charles W. Barnes, a grocer. In spite of its inclusion in the National Register of Historic Places, the house was bulldozed in the middle of the night in 1996, in violation of a historic district designation. (Texas Historical Commission.)

This building at 2304 San Antonio Street was the home of David Franklin Houston (1866–1940) during his time as professor of political science at the University of Texas and as its president from 1905 to 1908. He also served as president of Texas A&M University (1902–1905), US secretary of agriculture (1913–1920), and US secretary of the treasury (1920–1921). The house was later used as the University Club and was razed in 1961. (AHC PICH 02620.)

This Queen Anne building with a wraparound gallery at 2100 Nueces Street was the home of Col. William Henry Stacy, attorney, banker, and real estate agent in the early 1900s. Stacy was responsible in part for the development of Fairview Park, now known as Travis Heights. His name graces two parks in Travis Heights, Big Stacy (home to Austin's only public heated pool) and Little Stacy. The home was demolished in 1977. (AHC PICH 02297.)

Alexander Penn Wooldridge (1847–1930) was mayor of Austin from 1909 to 1919. His handsome Shingle Style home was built at Tenth and Guadalupe Streets. It is now the site of the present Travis County Courthouse. Wooldridge helped to organize Austin's public school system and was president of the City National Bank and the chamber of commerce. Wooldridge Square Park and Wooldridge Elementary School are named in his honor. (AHC PICH 04144.)

Edward Mandell House, an advisor to Woodrow Wilson and other state and national politicians, contracted Frank Freeman of Brooklyn, New York, to design this Shingle Style home at 1704 West Avenue in 1891. After decades of use by the Delta Zeta sorority, the home was abandoned in the early 1960s. The home was razed in 1968 after it burned, but the stone fencing was visible for some years afterward. (AHC C07986a.)

In 1873, Irish immigrant Michael Butler moved to Austin, where he founded Butler Brick Works, predecessor to the Elgin-Butler Brick Company. In 1887, Little Rock architect Thomas Harding designed Butler's grand new house at 309 West Eleventh Street. One of Austin's great lost architectural gems, the Butler House was demolished in December 1971. Fragments of the house are scattered throughout Austin, including the Moorish-style arch from the main doorway, which sprouts from the grounds of the Zilker Garden Center. (AHC PICH 00630.)

Col. Jesse Driskill, of Driskill Hotel fame, built this Victorian home in 1885 from a design by Jasper Preston, who also designed Allen Hall at Huston-Tillotson University. The mansion was located at 2612 Whitis Avenue and later belonged to the E.M. Scarborough family of Scarborough's Department Store. The North University landmark was gutted by fire in 2001, though its sizeable carriage house, pictured below, was rescued and moved to the Lady Bird Johnson Wildflower Center. Through the generosity of the Scarborough and McDermott families, the structure is now used as a multipurpose educational facility. (Above, AHC PICH 02920; below, AHC PICH 06275.)

This is now a neighborhood, but it was once a pasture. The Scofield family bred registered Shorthorn cattle for more than six decades on land west of Pflugerville totaling over 2,000 acres. Scofield Ranch was sold off beginning in the 1970s, but its heritage lives on as the subdivision Scofield Farms and in the thousands of Shorthorn cattle across the United States descended from the classic Austin-bred stock. (AHC ND-58-C207-01.)

Two
Lost Austin Institutions

Austin has lost places, people, and things that are more than just historic—they are institutions. Some buildings, like the Armadillo World Headquarters, did not have much architectural merit, but housed plenty of memories. Austin's streetcar system was the primary means of mass transit for many years. Other institutions have either vanished or drastically changed, including the public events that entertained thousands of citizens, long before the internationally known music festivals that now grace Austin. (AHC C06255.)

For some 60 years, trolleys were a fixture on Austin streets. The city's first streetcars were mule-drawn, but electric cars followed in the 1890s, and an extensive network developed. Economic hardship, combined with the rise of the automobile and public buses, eventually caused their demise. Above, Carl Lyda (left) and Louis Kocurek (a brother of Austin icon Willie Kocurek) pose at a passing switch on West Sixth Street near the entrance to the Confederate Men's Home about 1920. Below is a photograph of Austin's last streetcar, passing in front of Palm Elementary School in 1940. (Above, AHC PICA 08649; below, AHC PICA 15136.)

Originally a hangar purchased from the US government in 1940, the City Coliseum hosted a wide array of events during its existence—from citywide garage sales and political rallies to the Austin Symphony and rock and country acts. The last event to be held at the coliseum was the Austin Lyric Opera's production of *Rigoletto* on May 20, 2002. The coliseum was closed and demolished in 2002 as part of the redevelopment of Palmer Auditorium into the Long Center for the Performing Arts. The site is now Butler Park (Town Lake Park). Above is the coliseum in 1949, with the city water treatment plant under construction in the foreground. Below is a photograph of the interior in the late 1950s. (Above, AHC PICA 00779; below, AHC PICA 21514.)

For some years, the City Coliseum hosted weekly wrestling matches featuring regional greats like Ivan Putski and the Von Erichs. In this c. 1975 photograph, legendary wrestler José Lothario signs autographs for fans at the back door. (Author's collection.)

Disch Field was adjacent to the City Coliseum and opened in 1947, hosting many minor league teams. Named after Billy Disch, Longhorn baseball coach from 1911 to 1939, the field was home to the Austin Pioneers from 1947 to 1955, the Austin Senators from 1956 to 1964, and the Austin Braves from 1965 to 1967. Austin has not had a minor league team since 1967. (AHC PICA 14308.)

The Austin Pioneers played such teams as the Gainesville Owls, Greenville Majors, Temple Eagles, Texarkana Bears, Waco Pirates, Wichita Falls Spudders, and the Lubbock Hubbers. Some of its famous former players who went on to the major leagues include Al Unser, Al LaMacchia, and George Hausmann. The above photograph shows the 1949 Pioneers, including future major leaguers Prince Oana and George Estock. Below, Austin Brave Felix "The Cat" Millan is pictured in action around 1965. (Above, AHC PICA 06092; below, AHC C07466.)

47

Few citywide events were more anticipated than the annual livestock show and rodeo. The closest thing Austin had to a county fair was started in 1940 and attracted thousands from all over Central Texas. Sponsored over the years by the city, the county, and the Austin Chamber of Commerce, the Austin–Travis County Livestock Show commonly opened with a large parade down Congress Avenue and occupied the grounds of the City Coliseum. It moved to the Travis County Exposition Center in 1983 and is now called The Star of Texas Fair and Rodeo. Above, Del Valle rancher Gordon Smith (wearing suit) displays his 1967 grand champion steer. The c. 1956 photograph below shows an opening day parade. (Above, AHC C00837; below, AHC PICA 00021.)

The livestock show was an important activity for young Austinites who participated in Future Farmers of America and 4-H programs. Above, McCallum High School students pose with their prizewinning rabbits in 1962. Below, an early 1970s image shows an unidentified youth handling his charge. (Above, AHC AS-62-35279A-01; below, AHC PICA 11292.)

49

For many years, Austin had only one television station. KTBC signed on the air on November 27, 1952. Owned by the Lyndon Johnson family's Texas Broadcasting Company, it carried all four major networks at the time: ABC, CBS, NBC, and DuMont. The photograph at left shows the original location of KTBC at the Driskill Hotel. Below are the station's cameras, Ralph and Fappy Lou. KTBC erected its own building at Tenth and Brazos Streets in 1960. (Left, AHC ND-56-244-01; below, AHC PICA 28482.)

As in other cities, Austin had a live children's show for many years. KTBC's *The Uncle Jay Show* was hosted by the genial Jay Hodgson (1923–2007) with his sidekick, "crusty, hunnert-year-old trader" Packer Jack Wallace, from 1953 to 1977. The show featured cartoons and an on-screen studio audience of local children. Above, Uncle Jay—in his trademark coveralls—plays a game with the kids while Packer Jack and Piper, the organist, assist. Below, Packer Jack entertains young guests. (Above, Texas Archive of the Moving Image; below, AHC PICB 17938.)

Many remember the noontime program *Women's World*, first hosted by Jean Boone, sister-in-law of Zachary Scott and John Steinbeck. Renamed *The Carolyn Jackson Show* after its sparkling second host, the latter incarnation aired from 1968 to 1980 as Jackson—perhaps the most visible woman in Austin television—interviewed celebrities and offered up news and tips on diet and exercise. (Texas Archive of the Moving Image.)

Radio station KNOW originated in 1925 as KUT-AM 1490; in 1926, its call letters were changed to KNOW. Before rock 'n' roll, university physics professor Paul Boner played a live noontime organ program. The station signed off in 1989 after operating for 64 years. Notable 1960s DJs included Jay Allen and Paul Harrison; 1970s DJs included Joe Gracey, Michael Lucas, and Dave Jarrott. (Michael Lucas.)

Local radio airwaves in Austin were dominated for years by KTBC-AM, later KLBJ, where Austinites listened to Cactus Pryor and Jack Wallace on the *Cac and Jack Morning Show* during the 1960s and 1970s. Pryor (1923–2011) was a natural wit and an Austin radio and television pioneer. Here, Cactus (right) and Jack (who died in 1973) share a laugh in the booth. (AHC PICA 05760.)

Leonard Masters was *the* voice of Classical 89.5 KMFA from 1967 to 1994. Masters (1928–1996) was, according to "The Story of KMFA" on the station's website, "very tall, very bald, and very overweight," and his unforgettable voice was widely known to Austin listeners for his exacting pronunciation of foreign names and compositions. He came to radio through Dale Jones, who owned High Fidelity, Inc. and started Austin's first FM station, KHFI. (Classical 89.5 KMFA.)

Spanish-language radio in Austin dates back to the 1950s, when KVET included Spanish-language news and music on *Noche de Fiesta*. The dean of Spanish-speaking DJs in Austin, Marcelo Tafoya, had shows on KUT, KAZZ, and KGTN in the 1960s. This photograph shows the exterior of radio station KTXN and its marquee advertising the program *Cita con las Estrellas* ("Date with the Stars"). (AF Radio, R0300(22).)

KVET was started in 1946 by World War II veterans and political legends J.J. "Jake" Pickle and John Connally. Long before adopting its country format, KVET made history by featuring programming for black and Hispanic audiences. Piano professor Lavada Durst, shown at right, was the first black disc jockey in Texas, known as "Dr. Hepcat." The good doctor became popular enough to issue a Jive Talk dictionary. (Author's collection.)

KOKE-FM was the birthplace of the "Progressive Country" radio format. A station that defined Austin's eclectic tastes, KOKE was symbolized by its "Super Roper" logo and promoted by DJ Joe Gracey, who lionized Willie Nelson and outlaw country but was never above tossing in some Bob Wills, Ray Charles, or Frank Sinatra. Gracey recorded many artists in the studio's basement, dubbed "Electric Graceland." (Author's collection.)

Another "lost," oft-overlooked institution in Austin was the institution of racial segregation. This 1960 photograph shows a sit-in at an unidentified diner. (AHC AS-60-27281-1.)

Discriminatory Jim Crow laws segregating African Americans and Mexican Americans in housing, transportation, business, and education pervaded Austin until the Civil Rights Act and other events precipitated change. In this image from 1960, a protest takes place in front of the Woolworth's on Congress Avenue. (AHC AS-60-272-60-1.)

Got your Skipper Pin? The Austin Aqua Festival, better known as Aqua Fest, was held the first week of August on the shores of Town Lake (now Lady Bird Lake) for over 30 years. It was created in 1962 to promote Austin and the Highland Lakes as a vacation destination and to boost the local economy. Art Linkletter was the event's first headliner. The festival offered many water-related events, such as a 150-mile canoe race, fishing contests, a sailing regatta, and an illuminated nighttime parade on the lake. This photograph shows the 1978 Aqua Fest night parade. (AHC PICA 28298.)

The Aqua Festival had plenty of fun on land, including beauty pageants and live music nights and dances. At left, Katherine Louise Anderson is crowned Miss Austin Aqua Festival 1980. Musical acts ranged from Tejano to Czech to country, and featured artists as varied as Screamin' Jay Hawkins, Roy Orbison, George Jones, and the Ramones. Below, an unidentified couple cut the rug on a Western Night in 1976. (Left, AHC A5200(19); below, AHC PICA 11230.)

In 1956, the Women's Art Guild was formed to support the Laguna Gloria Art Museum (now part of the Austin Museum of Art). For years, the guild presented the annual outdoor art festival Fiesta on the grounds of Laguna Gloria, until 1999, when it moved downtown and was renamed the Austin Fine Arts Festival. The above photograph shows patrons of the guild in 1971. In the 1970s image at right, kids enjoy Fiesta and its children's component, Safari. (Above, AHC PICA 11544; right, AHC PICA 10200.)

59

Eeyore's Birthday Party began in 1963 in Eastwoods Park as a spring party and picnic for Department of English students by Lloyd W. Birdwell Jr., Jean Raver, and Jim Ayres. It is named for Eeyore, the chronically depressed donkey in A.A. Milne's Winnie-the-Pooh stories. The event was originally geared toward children, while adults could discreetly sip keg beer. Though it began as a UT tradition, it subsequently became a much more adult affair after it moved to Pease Park in 1974. Above, children greet a flower-draped Eeyore in the early 1970s. Below, children are shown dancing around the maypole, a tradition that continues today. (Above, AHC PICA 00556; below, AHC PICA 00554.)

> **S.M.F.C.**
>
> This is to certify that Rosemary Moore is a member of the Texas Union's SATURDAY MORNING FUN CLUB
>
> by my hand, _S. U. Muik_
> head, SMFC, in Austin, Texas, 1973

The Saturday Morning Fun Club ran from 1969 to about 1983 during the academic year at the university's Texas Union Theater. A throwback to the kiddie matinees of yore, it featured free G-rated films, from the Marx Brothers to Abbott and Costello to American International horror movies, preceded by up to an hour's worth of cartoons and Flash Gordon–type serials. About 45 minutes before showtime, hippies and kids alike helped themselves to pin-feed computer paper to make and fly endless paper airplanes. In the early years, Santa and Pilgrims made holiday appearances, handing out candy to the kids and—reportedly—adult treats to the grown-ups. (Rosemary Moore.)

The Methodist Student Center at 2434 Guadalupe was an Austin institution because of its multifaceted uses. Designed by Henry John Steinbomer, the center was home to the Texas Methodist student movement, now the Wesley Foundation. It was a multipurpose gathering place for young people from the 1950s through the 1970s and served as a focal point for war resistance and many civil liberties causes. The student center was razed in 1980 to make way for a parking lot. The above photograph shows the center as it appeared in the late 1950s. The photograph below shows Carlos Lowry's 1983 mural on the site of the center, commemorating the social movements and activists of Austin and the center itself. The mural was destroyed in 1999. (Above, Wesley Foundation; below, Mariann Wizard.)

Beginning in the late 1960s, artists and others began selling a variety of unique handcrafted items on the sidewalks of the Drag. This grew into dozens of sellers and, due to sidewalk congestion, the People's Renaissance Market was established formally by the city in 1973. In 1985, the street was permanently closed to traffic, and a Capital City Improvement Project led to what has become the Plaza at Twenty-third Street. A mural facing the market created in 1974–1975 depicts Austin and campus-area icons and structures. (Above, AHC PICA 02931; below, AHC PICA 02933.)

Most remember her as "Bicycle Annie," but her name was Zelma O'Reilly. A fixture on the Drag from the 1940s through the 1980s, she briefly published a newspaper, *Up And Down the Drag*, and ran for president of the United States in 1948. Until an accident required her to use crutches, she was frequently seen on her bike. Annie was fiercely independent up until her death in 1991. (ASE 84 86-2/Brad Doherty.)

The Lone Star Beer sign at approximately 2606 Guadalupe Street was an icon of the Drag when it was installed in the 1960s. No mere advertisement signage, this colossal sign on towering I-beams was visible from a mile away and moved with an unusual reverberation when struck with a rock or other hard object. The sign was removed in the 1990s. (Author's collection.)

Back when the word "underground" was equated with vibrant political and social activism, Austin was home to a number of news and arts publications. Austin's first underground paper, *The Rag*, was published from 1966 to 1973, and covered antiwar marches, the Black Panthers, UT regents exposés, incidents of police brutality, and the nascent anti–nuclear power movement. In a lighter vein, cartoonist Gilbert Shelton's Fabulous Furry Freak Brothers first appeared in the pages of *The Rag*. The late activist George Vizard is pictured here in 1967, selling *The Rag* on the Drag with his wife, Mariann. Vizard was murdered, and his assailant was later discovered to be a police informant. (Thorne Dreyer/*The Rag*.)

The Rag covered many stories and issues that mainstream newspapers would not. This image shows the front page of vol. 1, no. 12—the January 9, 1967, issue. (Thorne Dreyer/*The Rag*.)

At right is a *Rag* cover by JFKLN (Jim Franklin), the artist most responsible for making the armadillo Austin's mascot. (Thorne Dreyer/*The Rag*.)

On the heels of *The Rag* came another alternative newspaper, the *Austin Sun*. Founded by Jeff Nightbyrd and Michael Eakin, the *Sun* featured investigative journalism but was significant for its coverage of the burgeoning Austin music and arts scene. Many writers, photographers, and artists—such as Alan Pogue, Michael Ventura, Big Boy Medlin, and future *Austin Chronicle* staffers—worked on the *Sun*. At right is a typical *Austin Sun* cover. (AHC Periodicals Collection.)

Austin also had its share of literary magazines. Pictured at left is issue no. 27 of *The Gar* from 1976, with cover art by Melanie Hickerson. (Author's collection.)

67

The Armadillo World Headquarters, known to all as the Armadillo, was Austin's legendary concert hall, located at 525 1/2 Barton Springs Road. Opened by Eddie Wilson and colleagues Jim Franklin, Spencer Perskin, Mike Tolleson, Bobby Hedderman, and Hank Alrich, the Armadillo was more than just a music venue, hosting other institutions such as the Austin Ballet Theatre and the Armadillo Christmas Bazaar. During its life, from 1970 to 1980, the former National Guard armory featured performers including Taj Mahal, Asleep at the Wheel, The Clash, B.B. King, Jerry Jeff Walker, Parliament-Funkadelic, Willie Nelson, Edgar and Johnny Winter, and the Pointer Sisters. The above photograph shows the 'Dillo's exterior. Below is the opening day poster by Jim Franklin. (Above, Steve Hopson; below, South Austin Popular Culture Center/Jim Franklin.)

The Armadillo had a legendary parking lot—the potholes were rivaled only by those of the original Soap Creek Saloon. A beer garden outside the ticketed entrance provided daytime diversion, which attracted hippies, rednecks, and a wide galaxy of characters. This photograph shows the main entrance to the Armadillo. (Gerald Swick/AHC 2000.016-2-61.)

At right is a c. 1976 aerial view of the Armadillo's beer garden. Author Edwin "Bud" Shrake is purportedly somewhere in the crowd. (South Austin Popular Culture Center/Jim Richardson.)

69

The Armadillo's interior was cavernous, with a capacity of 1,500 and a very sizeable stage. Whether patrons sat in a folding chair or on the funky carpet, they were never far from the action. The above photograph shows a typical crowd at an unidentified concert. Below, the stage is seen from the back of the building. (Above, AHC PICA 20337; below, South Austin Popular Culture Center/Jim Richardson.)

The 'Dillo's walls were decorated with murals by Jim Franklin, Micael Priest, Kerry Awn, Danny Garrett, Ken Featherston, Sam Yeates, Henry Gonzalez, Bill Narum, Gary McIlheney, and Guy Juke. Franklin's surrealistic works oozed off the walls, including one inside the main door (above) and another (right) on an exterior wall. In 1996, the restaurant Threadgill's World Headquarters was opened in south Austin, next to the site of the concert hall. It has become something of a shrine and is stuffed to the rafters with everything Armadillo. (Both, Nicki Turman.)

Immortalized in Jerry Jeff Walker's song "Charlie Dunn," the Capitol Saddlery and its legendary bootmaker, Charlie Dunn, made history at 1614 Lavaca Street in the little building with the big boot out front. Started in the 1930s by Buck Steiner in a former Austin firehouse, the Capitol Saddlery became famous for its boots and horse tack. At one time, the business produced saddles for Montgomery Ward and Sears and employed about 100 people. Dunn passed away in 1993; Buck Steiner was 101 when he died in 2001. The saddlery moved to another location in 2007. (Author's collection)

Three
LOST FOOD, DRINK, AND FUN

Food and entertainment has changed over time. In 19th-century Austin, social activity included German-style beer gardens. Paul Pressler's beer garden opened in the 1870s and operated for 30 years where present-day West Sixth and Pressler Streets meet. Part of the Pressler Brewery, it featured a bandstand under shady live oaks, a *schützenverein* (gun club), an alligator pond, and a private boathouse at the river. (AHC PICA 05968.)

Saloons and bars were ubiquitous in old Austin and for many years were the domain of men. A saloon row sprouted on the east side of Congress Avenue where visitors could drink, eat, and occasionally gamble. The photograph above shows an unidentified Austin saloon of the 1880s. The photograph below is of Otto Ulit's Speedway Saloon, which served a beer as popular today as it was back then—Lone Star. The Ulit family, who also operated a meat market, is the namesake for Ulit Street. (Above, AHC J00082; below, AHC PICB 12557.)

"The JJJ Tavern Welcomes You" sign at Sixth and Red River Streets greeted patrons of Joe J. Joseph's bar from 1950 to 1982. It was a landmark bar of old Sixth Street that featured live music and was known for its ever-changing cast of characters. (AHC PICA 10488.)

Austin's Asian community was very small until recently. Chinese restaurants were scarce, and among the earliest were Harry Ng's Sam Wah Café at 223 Congress Avenue, and Lim Ting, which survived into the 1980s. In this photograph, Pres. Harry S. Truman is seen making a whistle stop in Austin during the campaign of 1948, directly in front of Sam Wah Café. (AHC ND-48-137-07.)

Many in decades past claimed that Toonerville had Austin's best old-fashioned hamburger. It was located at 5412 Georgetown Road, better known as Guadalupe Street. (AHC C07087.)

The Stallion Drive-In Restaurant, with its traditional Southern menu, stood at 5602 North Lamar Boulevard, from its opening in 1948 to its closing in 1984. Its western decor, low ceilings, and reasonable prices made it a beloved establishment for decades. This 1950 view shows the original building, which was added onto several times. (AHC ND-50-235-01.)

Austin's Triple XXX Root Beer "thirst station" was at 2801 Guadalupe during the 1920s and 1930s. Later, it became a Pig Stand franchise, which lasted until about 1970. Folks in the 1970s and 1980s remember the building as the Nieuw Hope Inn and later the 24-hour diner the Lazy Daisy. (AHC C05419.)

Sid's, at 3501 North Lamar Boulevard, was a venerable restaurant operated by Sid Tetens from 1962 to 1989. A Pflugerville native, Tetens served up standard American fare and generous mixed drinks to several generations of Austinites within his establishment's stone-walled exterior. (*Austin American-Statesman*.)

Matt's El Rancho is far from forgotten, but the restaurant's humble origins are often overlooked. The original location was at 302 East First Street, a tiny establishment with only about 10 tables. Matt worked the front, while his wife, Janie, worked the kitchen. As Matt's reputation grew, the restaurant moved across the street to 301 East First. Above, Matt poses with the Budweiser Clydesdales at the original location. Below, a vintage postcard shows the second location in the 1970s. (Above, Matt's El Rancho; below, author's collection.)

El Matamoros, not to be confused with Matt's El Rancho, was on East Avenue between Fifth and Sixth Streets. Without a doubt, its animated Quetzalcoatl sign was one of the wildest specimens of neon signage in Austin. The establishment was operated by Monroe Lopez, who also owned three other memorable Austin Mexican restaurants: El Charro, El Toro, and Monroe's. Together, they made up "The Big Four—El Mejor." (AHC ND-57-516-03-A)

Victor's Italian Village at 2910 Guadalupe Street was a longstanding bastion of Italian food in Austin. Started by Victor Nardecchia, it was originally located at 409 West Twenty-third Street (above). In the much roomier Guadalupe location (below), Nardecchia is waiting on Dr. Myron Begeman and his wife, Hazel (second from right), and an unidentified friend. Begeman was a respected University of Texas mechanical engineering professor. (Above, AHC C07107; below, AHC PICA15957.)

In 1932, Harry Akin (1903–1976) opened Austin's first diner, the Night Hawk, on the corner of Congress Avenue and Riverside Drive. Akin's motto, "There's Nothing Accidental about Quality," proved true, as he opened six more locations, including the venerable Frisco Shop. Except for the Frisco, all of the Night Hawks have closed, but many Austinites still fondly remember the steaks, burgers, and kids' menu. Above is the Night Hawk No. 1 on Congress. Below is the Night Hawk neon sign, which was rescued and ensconced at Threadgill's South. (Above, AHC C06035; below, Threadgill's.)

The Coxville Zoo was a homegrown attraction opened by gas station owner Alvin Cox in 1939 at the present-day intersection of Yager Lane and North Lamar Boulevard (then called the Dallas Highway). It started with a monkey and grew to include dozens of exotic animals, sometimes featured in spots on *The Uncle Jay Show*. It also had a rock garden and rental cabins. The construction of Interstate 35 and opposition from the Humane Society and neighbors contributed to Coxville's closing in 1970. Some of the zoo's remains still stand at the edge of Walnut Creek Park. At left is the entrance to Coxville, and below is one of its residents, with Cox's gas station in the background. (Left, AHC PICA 27750; below, AHC PICA 27751.)

Bowl-o-Rama, which opened in 1958, was one of Austin's finest bowling lanes. It was open 24 hours a day and was originally owned by Bobby Layne (1926–1986), the legendary Longhorn quarterback who also played 15 professional seasons for the Bears, the Lions, and the Steelers. It was situated at the corner of Barton Springs Road and South Lamar Boulevard and has been repurposed into several businesses since closing in the late 1980s. (AHC ND-59-A003-01.)

Kiddieland was a pint-sized amusement park at the corner of Barton Springs Road and South Lamar Boulevard, operated by Kenneth Wallace during the 1950s and early 1960s. Another park of similar vintage was near the corner of South Lamar and Riverside Drive. Here, wee ones enjoyed pony rides, rocket-ship rides, and a scaled-down Ferris wheel. (AHC ND-50-217-01.)

The restaurants of entrepreneur Ralph Moreland (1927–2009) were Austin dining institutions for over 50 years. They included the Holiday House chain, which served "flame-kissed hamburgers." The Barton Springs Road location, shown above and below, was decorated in South Pacific and American Indian themes, and visitors were greeted by totem poles and a moat that held Charlie, the pet alligator. At one end of the restaurant was a glassed-in aviary with tropical birds. Moreland was not restricted to fast food; he was also known for the upscale restaurant Convict Hill in Oak Hill. (Above, AHC PICA 04695; below, AHC PICA 26983.)

Some of Ralph Moreland's restaurants featured eclectic architecture. This is the Holiday House located on Airport Boulevard. (AHC PICA 26984.)

Moreland's empire also included 2-J Hamburgers on North Lamar Boulevard, where children could ride an impossibly slow carousel. The carousel's animals had flat heads to accommodate trays. (AHC ND-50-217-01.)

Christie's Seafood was another restaurant with unique architecture. It was part of a small chain started in the Houston area in 1917. The Austin location was at 108 Barton Springs Drive, where the Hyatt Regency Austin now stands. Besides a choice view of Town Lake (now Lady Bird Lake) from the water's edge, it also had a dock for a boat that gave tours up and down the lake. (AHC PICA 09433.)

"*Austin's Most Unique Restaurant*"
FEATURING A COMPLETE MENU

UNCLE VAN'S PANCAKE HOUSE

PREMIUM CORN FED STEAKS
HOME MADE PASTRY
TRY OUR FAMOUS CHEESE CAKE

Home of World Renowned Pancakes
OVER 32 VARIETIES
Served Steaming Hot With Whipped
Butter & Your Choice of Syrups!

"Try Our Country Style Sausage"
FRIED CHICKEN – CREAM GRAVY – HONEY
OUR PANCAKES ARE A FAVORITE FOR
BREAKFAST – LUNCH – SUPPER
Chicken Fried Steak & Veal Cutlet
SEA FOOD – SPAGHETTI – SANDWICHES
HOT LUNCHES Mon. Thru Fri.

OPEN
24 HOURS EVERY DAY

415 W. 19th GR 8-3912
JUST OFF THE DRAG
Also in Abilene, Houston & Kerrville

Uncle Van's Pancake House stood at 415 West Nineteenth Street. The 24-hour restaurant featured 32 varieties of pancakes, a menu beyond breakfast food, and was a well-liked—if somewhat run-down—establishment. (Scott Sayers.)

The Barn on MoPac Expressway was the brainchild of restauranteur Jack Ray, who opened Austin's biggest steak house in 1961. An upscale place that included a large bar complete with a lady in a red velvet swing, it was a hangout for Texas governors such as John Connally, Preston Smith, and Dolph Briscoe. One of its hallmarks was fresh bread brought out with a massive block of Swiss cheese. The Barn was supplemented by the Silo and the Little Barn, a party facility. Ray was also the proprietor of the infamous Feedlot Steakhouse on FM 2222, where two live steers poked their heads through a wall in the bar. (Above, AHC PICA 05827; below, AHC PICA 16055.)

By many accounts, Leslie's Chicken Shack, at the corner of North Lamar and North Loop Boulevards, had some of the best fried chicken in Austin. It was one of a chain of restaurants originating in Waco. Besides its homespun barnyard decor, it offered a mind-blowing assortment of prizes for youngsters who finished their plates. Its murals, such as the one seen here, were uncovered in 2011. (Scott Conn.)

Is the line around the building enough of a popularity indicator? Youngblood's, which had an Austin location on South Congress Avenue, was part of another Waco-based chicken chain empire. Youngblood's boasted, "We hatch 'em, we raise 'em, we fry 'em." From the mid-1940s through the mid-1960s, Youngblood's was the fried chicken king of Texas before a flood of national chicken franchises and financial troubles forced it out of business. (AHC ND-58-149-01.)

For many years, Carrie Lundstedt's "Tamales" sign was visible on Speedway. From the late 1920s to 1988, Lundstedt was the Tamale Lady of Hyde Park and sold her homemade delights to anyone willing to stop by her home. She lived to be 101, and her product was shipped to places around the world. This photograph of Lundstedt is from 1971. (AHC PICA 11967.)

> Handcrafted sandwiches on "homemade" bread. Serving the best food for the least amount of money in the shortest amount of time.
>
> On the drag & Littlefield Fount.

Long before the food truck revolution, Roland DeNoie pioneered street food with Salvation Sandwiches in the 1970s and early 1980s. His motto, "Live Good . . . What is the Harm?", was reflected in the modestly priced sandwiches served on fresh baked bread, sold mostly on the Drag. The Austin City Council fought DeNoie, who noted that tamale vendors were not barred from the streets. The US Supreme Court agreed with DeNoie—and street vendors scored a victory. At left is an advertisement for Salvation Sandwiches. Below, DeNoie (left) poses with business partner and Planet K entrepreneur Michael Kleinman and Kleinman's son Matt. (Left, author's collection; below, Mariann Wizard.)

A sign of changing times in Austin culture and cuisine was heralded by the arrival of Vietnamese immigrants. From the late 1970s through the 1990s, Saigon Eggrolls—usually found at street corners facing the campus—fed many a University of Texas student and staffer eating on a budget. (AHC PICA 10377.)

Les Amis—the closest thing to a bistro in Austin—opened in 1970 at Twenty-fourth and San Antonio Streets with no pretensions. Until its demise in 1997, it was one of the freewheeling hangouts of choice for university students, hippies, and bohemians. Even a few UT faculty were known to hold office hours there. Richard Linklater's 1990 film *Slacker* and a documentary immortalized Les Amis on film. (Alan Pogue.)

Hector's Taco Flats ("Over 2000 Tacos Returned") was a hole-in-the-wall at 5213 North Lamar Boulevard run by Hector Alvarado. Its cheap pitchers, tasty nachos, and jalapeno-eating contests were legendary. Tasteless jokes about the meat's origins abounded. The laid-back cantina with picnic tables and folding chairs attracted cosmic cowboys, UT students, bankers, and bikers. (Jenna McEachern.)

Several Austin nightspots were important incubators of the rock and psychedelic scene during the 1960s. Originally a Dixieland jazz venue, the New Orleans Club was located at 1123 Red River Street and featured the legendary Ernie Mae Miller on piano throughout the 1950s and 1960s before it became a proving ground for Austin groups such as the 13th Floor Elevators. Today, the building is a part of Symphony Square. (AHC ND-50-A002-02.)

The Jade Room ("The In Place for the In Crowd"), at Fifth and San Jacinto Streets, vied with Club Saracen and the New Orleans Club for Austin's burgeoning rock bands during the late 1960s. The 13th Floor Elevators played their first show here. (Bob Simmons.)

Before the Armadillo, Austin's premier alternative music establishment was the Vulcan Gas Company. Opened by Houston White in 1966, the spacious club at 316 Congress Avenue featured local favorites, but also played host to touring acts like Johnny Winter, the Fugs, and blues master Mance Lipscomb. It closed in 1970, and the building later housed other clubs, including Duke's Royal Coach Inn. (South Austin Popular Culture Center/Gilbert Shelton.)

Nothing remains of the Split Rail at 217 South Lamar Boulevard but memories and some recordings, but, oh, the memories. This intimate bar catering to cedar choppers and longhairs alike was originally a drive-in; a beer garden was later enclosed. A sign admonished, "No Dancing, Standing or Fighting." Few heeded the sign and enjoyed the music of Freda and the Firedogs, Butch Hancock, Bill Neely, and Doug Sahm. (Ken Hoge.)

Soap Creek Saloon, started by George and Carlyne Majewski in 1973, was originally located at 711 Bee Caves Road. *Texas Monthly* quipped in 1974, "This dilapidated building attracts good musicians and people ready for a good time. The acoustics are dreadful, the people (mostly freaks and kickers) are friendly. Some of the Sunday jam sessions really get it on." Its pitted and rutted parking lot was as legendary as the stars who played there. Soap Creek found later homes at the historic Skyline Club on far North Lamar, and on South Congress at Academy Drive. The above photograph shows the original Soap Creek on Bee Caves Road. Below, the 1977 George Majewski Lookalike Contest is being held, featuring entertainment by the Uranium Savages. The winner of the contest was not the cow, but her leftover "gift." (Both, Ken Hoge.)

After the Armadillo, one of Austin's most beloved music halls was the visually unimpressive shed called Liberty Lunch. This bare-bones stage and beer garden was opened in 1976 by Shannon Sedwick and Michael Shelton of Esther's Follies. When it needed a roof, some of the wood and metal from the demolished Armadillo was repurposed. Its cavernous size made it ideal for traveling acts too large for small clubs. From local acts to Nirvana to Sun Ra, Liberty Lunch became an important tour stop. Into the 1990s under J'Net Ward and Mark Pratz, it hosted many punk and alternative rock groups, but was forced to close in 1999 to make way for downtown redevelopment. (Above, AHC PICA 25970; below, Pamela C. Patterson.)

Austin's vibrant Tejano music scene once included several nightclubs in southeast Austin, such as Marie's Tearoom No. 2 and Benny's Club, and on Sixth Street, such as the Chaparral, La Plaza, and the Green Spot. These unpretentious joints were home to authentic Austin Norteño music and *orquestas* featuring musicians such as Manuel "Cowboy" Donley and Ruben Ramos, and plenty of touring acts. In these photographs, couples sway to the music at La Plaza; Johnny Degollado, "El Montopolis Kid" (right), is on *accordeon*. (Right, AHC PICA 29506; below, AHC PICA 26500.)

Raul's Club at 2610 Guadalupe Street was opened on New Year's Eve 1977, by Roy "Raul" Gomez and manager Joseph Gonzales (1945–1996). Prior to Raul's, the joint had many colorful names, including the Touchdown Lounge, the Pink Lizard Lounge, the Buffalo Gap, Gemini's, the Hungry Horse, and Sunshine's Party. Despite its intended Mexican American clientele, Raul's was quickly swept up into the Texas punk rock scene and became its epicenter between 1978 and 1982. It made headlines in *Rolling Stone* on September 19, 1978, when the Huns were arrested after an altercation with Austin police. Several live recordings were made at Raul's, including *Live at Raul's*, recorded in 1979. In the above photograph, The Standing Waves pose outside the club; at left, the Skunks perform in 1978. (Above, David Fox; left, Dolph Briscoe Center for American History, University of Texas at Austin.)

The Rome Inn was a restaurant owned by Jack Davis, who sold it in 1975 to Arlo and Mike Watson, who converted it into a nightclub featuring the likes of Alvin Crow, the Fabulous Thunderbirds, and "Blue Monday" with Paul Ray and the Cobras. On other nights, one might see an ascendant Stevie Ray Vaughn. It closed in 1980. Later, as Studio 29, it hosted spirited punk rock acts. (Ken Hoge.)

Club Foot was a converted warehouse located at the corner of Fourth and Brazos Streets. It had a reputation as a punk rock venue for its support of local and touring bands, but it also booked a wide variety of other types of music. It was known in other guises as the 404 Club, the Boondocks, Rush's, and the Night Life. The building was demolished in 2000. (Mark Dean.)

The Black Cat Lounge was a beloved Sixth Street landmark and institution opened in 1984 by Paul Sessums Sr. Home to regular gigs by Soulhat, Joe Rockhead, Kelly Willis, The Robison Brothers, Chris Duarte, Ian Moore, and Dale Watson, it was a crowded haven for bikers and fans of punk, country, and neo-rockabilly. Even after Sessums's passing in 1998, his family carried on until the club burned down in 2002. (Both, Sasha Sessums/Sessums family.)

The Austin Theater opened in 1939 and showed first-run movies until the mid-1970s. As the surrounding South Congress area deteriorated, the Austin closed, but it reopened in 1977 as Cinema West, which showed X-rated movies until it closed for good in 1998. A rescue of the unique building and its marquee in the 2000s brought it new life as office and studio space. (AHC C07084.)

The Chief Drive-in was the king of Austin's drive-in theaters from its opening in 1947 until its slow demise in 1973. Originally built by Eddie Joseph, it was listed as being located on "Dallas Highway," now North Lamar Boulevard, at Koenig Lane. (AHC PICA 27706.)

A centerpiece of the Drag, the Varsity Theatre at the corner of Guadalupe and Twenty-fourth Streets opened in 1936 and served as a first-run and then an art house theater until it closed in 1990. Various tenants have come and gone over the years, but the popular outdoor mural, created by Carlos Lowry in 1980, remains. Before splitting into two screens, its infamous balcony was the preferred seating for hordes of daters, and later, stoners. The above photograph shows the Varsity about 1936. Below is a view of the interior of the lobby, also decorated with Lowry's murals. (Above, AHC PICA 06734; below, AHC PICA 24704.)

Four
Lost Austin Businesses

Little is known about the Johnson and Scott barbershop at 310 East Sixth Street, but Hubert Jones's promotional photograph from about 1885 demonstrates the upward movement of African American businesses in Austin. (AHC PICA 13518.)

Danish immigrant Karl Hans Peter Nielsen Gammel (1854–1931) was Austin's—and the state's—first significant bookseller. Established in 1878 on Congress Avenue, the bookstore's fame was cemented by rescuing from fire, compiling, and reprinting early state legislation. The first 10 volumes of Gammel's *Laws of Texas* (1822–1897) are must-haves for any Texas attorney. (AHC PICA 28685.)

Another important bookseller in Austin was John Jenkins, internationally known rare book dealer and publisher from the 1960s through the 1980s. He was said to have sold over 500,000 pieces of Texana worth more than $30 million and was involved in both reputable and shady adventures. Also known for his gambling, Jenkins mysteriously died in 1989. In this photograph, Jenkins inspects the damage from one of three warehouse fires. (AHC PICA 29504.)

Before chain department stores came to Austin, there was Scarbrough's on Congress Avenue. Established in 1893 by one of Austin's pioneer families, Scarbrough's was a downtown destination until the early 1980s and the advent of shopping malls. The building seen in this photograph opened in 1931; its interiors were modeled after Chicago's Marshall Field's. This mid-1930s image shows the first-floor center aisle. (AHC C03663.)

Among the many women's clothing shops in Austin was the respected and locally owned Chenard's, seen here during the 1950s at its Drag location. Originally Snyder's Smart Shop and later known as Snyder-Chenard's, the store was started by Louis Snyder, who cleverly named the store after his sons Chester and Bernard. (AHC ND-56-330-02.)

Dewey Bradford's paint store at 201 West Ninth Street, pictured here, and later at 401 Guadalupe, was a source for art supplies and framing, but it also doubled as a gallery. Bradford was the dealer for famed bluebonnet painter Porfirio Salinas and was a close friend of Lyndon Johnson, who admired and hung Salinas's works in the White House. (AHC C05737.)

Street vendors in years past were a common sight downtown, just as they are today. Will Kendall was a familiar peanut and popcorn vendor who catered to the theater crowds. In this photograph from 1910, Kendall is probably working outside the Casino Theatre at 702 Congress Avenue. (AHC PICA 25812.)

These scenes of C.C. Sullivan's fruit and vegetable stand at 2824 Guadalupe Street in 1936 show views of the business looking toward Twenty-ninth Street (above) and looking south down the Drag (below). Sullivan's calls to mind long-gone produce stands such as Fred's, near Thirty-fourth Street and Lamar Boulevard. In the below photograph, the Triple XXX Root Beer stand, which was also a Pig Stand, can be seen across and down the street. (Above, AHC PICA 02921; below, AHC PICA 04847.)

For decades, vendors on the Drag have hawked everything from newspapers to food to flowers, but only in 1972 did the Austin City Council establish an ordinance creating the People's Renaissance Market. The Flower People were a ubiquitous sight on Austin street corners from the early 1970s to the late 1990s. A number of Austin luminaries were Flower People alumni, including former council member Max Nofziger and music icons Gary Floyd and Randy "Biscuit" Turner. In the above photograph, a vendor sells flowers in front of the University Co-Op in 1972. At left, Henrietta Jimenez hawks her wares with baby in tow in 1977. (Above, AHC PICA 03706; left, AHC PICA 10577.)

Walker's Austex Chile Company existed in Austin from the 1910s until it merged with Frito-Lay in 1961. Today's Republic Square, framed by Guadalupe, Fourth, San Antonio, and Fifth Streets, was formerly known as "Chili Square" because of the large factory. The nearby park was a focal point of the Mexican American community. These photographs show the exterior in 1941 (above) and an undated interior of the factory with employees (below). (Above, AHC PICA 19193; below, AHC C05842.)

Was the first mechanized tortilla factory in Austin? No one knows for sure, but the Austin Tortilla Factory (above), owned by Crescenciano Segovia, located at approximately Second and Lavaca Streets, produced 300 tortillas daily. The machine at left was imported from Mexico and was later purchased by Tony's Sanitary Tortilla Company. Jesse E. Segovia Street is named for Crescenciano's son, an East Austin civic leader and defender of the Fiesta Gardens neighborhood. (Above, Dolph Briscoe Center for American History, CN2902; left, AHC PICB 14156.)

William E. "Rooster" Andrews (1923–2008) stood "five feet on the dime" and was a former Texas Longhorn who turned his love of sports into a lifelong association with the University of Texas. Andrews founded a chain of sporting goods stores bearing his name in 1969. Raspy-voiced Andrews was the probable source of the ubiquitous Longhorn silhouette logo. (Flip Kromer.)

Austinites in the campus area shopped for flowers for all occasions at Eldon Powell's bright and great-smelling shop at 2001 Guadalupe. From the 1940s to the 1980s, Powell's supplied arrangements for all occasions, from cradle to grave, and probably bailed out more than a few spouses and suitors. "Just phone Greenwood 2-9273." (AHC City Directories.)

Not to be confused with the TCU coach of the same name, crusty Dutch Meyer (left) was one of several junk shop/antique dealers who operated for years on Red River between Sixth and Tenth Streets. Besides Dutch Meyer's Trading Post, there were places like Snooper's Paradise Pawn Shop (below), an inspiration for Doug Sahm's song "Groover's Paradise." Snooper's cavernous interior later inspired the name for the nightclub opened there, the Cave Club. (Left, AHC PICA 12396; below, AHC PICA 04253.)

Greyhound's competitor in Austin was the Continental Trailways system, whose Continental Bus Station Depot was located at 1001 Congress Avenue. In this moody 1952 nighttime view of the terminal's exterior, the capitol can be seen in the background. (AHC ND-52-155-02.)

The businesses in the 1000 block of East Sixth Street were an important source of pride for East Austin. The still-intact Buratti-Moreno building in the early 1930s housed the Buratti Grocery, Nash Moreno's Auto Repair, Roy's Taxi, and the Lopez Drug Store. In this photograph, Nash Moreno (fifth from right) poses with the fleet of Roy's taxis in front of his auto repair service. (AHC PICA 26317.)

"If you didn't buy it from the Big O, I KNOW you paid too much!" was the deliciously bombastic pitch of appliance dealer Oscar Snowden. Snowden was a fixture on Congress Avenue and is fondly recalled for his homegrown television spots. The jolly businessman was frequently joined by Betty Mayfield, touting the latest in washing machines and refrigerators. (AHC PICB 08629.)

Many older Austin businesses combined goods and services. German immigrant Ernst "Ernest" Eisenbeiser operated the East End Saloon and a grocery at the corner of East Twelfth and Comal Streets from about 1900 through the 1930s. The bar was a popular college student hangout into the 1940s; many years later, the same building housed the Shalimar Club. (AHC PICA 18436.)

Sam Slaughter's grocery stores were a common sight throughout Austin from the 1940s through the early 1970s and were a competitor with the Kash-Karry chain. This photograph shows the location at West Nineteenth Street and San Jacinto Boulevard. (AHC PICA 12779.)

Guajardo's Cash Grocery and Market at 809 Lydia Street, at East Ninth Street, was an East Austin mainstay for over 30 years. More than just a store, Guajardo's was also where Sonny Falcon perfected and helped popularize a now-famous staple of Tex-Mex cuisine: fajitas. (AHC ND-50-A104-01.)

Austin's first local chain grocer was Kash-Karry, started in 1920 by A.C. Knippa. The Knippa and Seiders families ran six locations until the 1980s, when most of the stores closed and the remaining were renamed Fresh Plus. The Seiders also operated a bathhouse at Seiders Springs on Shoal Creek. This photograph shows the Tenth Street and Congress Avenue location around 1930. Much of the staff are Knippa and Seiders family members. (Chad Seiders.)

Organic food stores have a long history in Austin. Spurred by the Austin Community Project food co-op movement in the 1970s, organic businesses and restaurants like the 28 1/2 Street Buying Club, Sattva, Wheatsville Co-op, Clarksville Health Food Store, Saferway, The Juice Factory, and The Health Kitchen offered healthy alternatives to Austin's meat-and-potatoes lifestyle. Clarksville and Saferway later joined forces to create Whole Foods. This photograph shows the interior of Good Food People, Inc. (AHC PICA 04982.)

Some of Austin's businesses of the past are closely identified with their owners. Rudy Castañon (1947–2005) opened El Porvenir grocery and bakery in 1979 in the Santa Rita neighborhood, dispensing wisdom and encouragement for East Austin youth. A valued community leader, Castañon was honored with a memorial resolution by State Sen. Gonzalo Barrientos. In this photograph, Castañon describes the uses of herbal remedies before his *yerberia*. (AHC PICA 29505.)

Few people could drive down South Lamar Boulevard in decades past without gawking at one of Austin's most iconic business mascots: the gigantic insect named "Willie N. Festus" sitting atop the revolving sign for the local franchise of Terminix pest control. Not to fear; Willie lives on as part of the vintage signage collection at Threadgill's South. (Ray Kluga.)

Smaller hotels and motels dotted Austin well in advance of the national chains. During segregation, African American travelers stayed at such East Austin establishments as the Rhambo Hotel and the Deluxe Hotel (above). The St. Elmo-tel, seen in the photograph below, was named after its location on St. Elmo Road. The hotel was demolished in 2006. (Above, AHC PICA 20871; below, AHC Postcard Collection.)

St. Elmo-Tel -- Austin's finest Motel
One Mile South of the Capital City -- U. S. 81

The Alamo Hotel at Sixth and Guadalupe Streets, razed in 1984, was the year-round home to such classic Austin characters as LBJ's bad-to-the-bottle brother Sam Houston Johnson; Barbette, a retired transvestite high-wire artist; and a pair of octogenarian sisters seen daily in the lobby. Many remember its basement massage parlor and Zeke's Cafe. Butch Hancock's 1980 live album *Firewater* was recorded in the hotel's smoky Alamo Lounge. (AHC ND-57-481-02.)

The 275-room Villa Capri Motor Hotel was built in 1958 alongside the new interstate, next to the university. It was popular with politicians, celebrities, and campus visitors. It had a restaurant and a ballroom; a nightclub, the Circus Room, was added in the 1970s. For many years, it was the postgame hideaway for Longhorn coach Darrell Royal. The Villa closed in 1987 and was demolished for university expansion. (AHC ND-59-4804-01.)

It is hard to imagine what North Austin looked like when its neighborhoods and first businesses appeared. Allandale Village, shown here in 1950, was one of Austin's earliest strip malls. It was developed by W. Murray Graham and for many years was owned by a five-man partnership that included Frank Knight. (AHC ND-54-224-01.)

Head shops are an important part of Austin's business folklore. Oat Willie's originated in 1968, when Doug Brown and George Majewski purchased the Underground City Hall at 1606 Lavaca Street, Austin's first head shop. Renamed Oat Willie's Campaign Headquarters at 1610 San Antonio Street, it had several locations, but most still remember the rambling old house and its accessories, gifts, posters, T-shirts, and underground comic books. (AHC PICH 06265.)

The White House on Lavaca Street was a competitor with Oat Willie's, along with other head shops/gift shops of the 1970s, such as the Magic Mushroom in Dobie Mall, the Texas Rose Emporium, and Gandalf's. (Author's collection.)

Nothing Strikes Back was Austin's psychedelic ice cream shop, located above a Kentucky Fried Chicken on the Drag. However, the ice cream was not the draw: its major hallmark was being lit almost entirely in black light. Jackson Pollock–like Day-Glo paint was on the walls, as were black-light posters. At left, a Kerry Awn advertisement embodies the shop's laid-back atmosphere. (Author's collection.)

Austin's homegrown record stores made the city a vinyl hunter's mecca in the 1970s and 1980s. Shops were all over the city—from Big Tex Gospel Records and Soul Zodiac on the eastside, to Maldonado's on the southside, to the Sound Exchange on the Drag. Inner Sanctum, started and owned by Joe Bryson from 1970 to 1984, was the epicenter of the campus-area stores, which included Record Town, Discount Records, Zebra Records, and others. From local music to the latest imports and concert ticket sales, Inner Sanctum had it all. The above photograph shows the entrance to Bluebonnet Plaza on Twenty-fourth Street, where the Sanctum was the centerpiece. Below, an in-store party for the Psychedelic Furs is taking place in 1980. Bryson is in the right foreground chatting up a customer; David Dictor of MDC/The Stains is left of him. (Both, Joe Bryson.)

Five

Endangered Austin

Preserving and protecting Austin's historic buildings and landscapes is vitally important. By demolishing Austin's historic structures and obscuring its geography, the character of Austin's cultural heritage is lost. A historic landmark preservation ordinance was passed in 1974, but many loopholes exist. In 1933, the legendary Kenneth Threadgill opened this Gulf filling station, which doubled as a tavern. It sat vacant until entrepreneur Eddie Wilson reopened it as Threadgill's. (AHC PICA 28326.)

Calling it a "guerilla war against historic Austin," *Texas Monthly* decried the 1974 demolition of the 108-year-old Shot Tower (see also page 14). Although an injunction was granted to stop Capitol National Bank from moving forward, it arrived too late to save the building from the wrecking ball. This structure and the Hunnicutt House were the catalysts for Austin's historic landmark ordinance. (AHC PICH 01943.)

Organized in 1873 by the Reverend Carl Charnquist, the Swedish Methodist Church built a sanctuary at Red River and Fifteenth Streets. Led by the Reverend O.E. Olander, the congregation moved to this site in 1898. Church property, then across from the capitol grounds at Colorado and Thirteenth Streets, was sold in 1956 for expansion of state offices. Renamed Memorial Methodist Church, the historic congregation moved to northeast Austin. (AHC PICA 03489.)

The pink granite Texas State Capitol defines Austin—and Texas. By law, tall buildings cannot block certain views of the capitol. With the fast-paced growth of the city and developers eager for residential and commercial projects, 30 view corridors are endangered. The views are priceless, and modifications would compromise a treasure that belongs to all Texans. (Author's collection.)

Variously known as Bellevue Place, the North-Evans Chateau, or Chateau Bellevue, the Austin Woman's Club was designed by San Antonio architect Alfred Giles in 1874. The French Romanesque residence rests on the bluff of Shoal Creek and was purchased in 1929 by the Austin Woman's Club. The building suffers from many preservation issues, and the club struggles to save its historic headquarters while continuing to serve the community. (Author's collection.)

The Texas School for the Blind and Visually Impaired, established in 1856, moved to its present location at Forty-fifth Street and Lamar Boulevard in 1917. The school is built on the cottage plan, with the historic main school building in the center. This image shows the campus layout around 1920. Many of the original buildings still exist. A complete remodeling of the campus occurred in 2010–2012. (AHC AF P6150 (47).)

The 11-unit Blue Bonnet Court at 4407 Guadalupe Street is one of Austin's last intact motor court motels. Built in 1928–1929 by Joe and Elizabeth Lucas, the motel is situated on the northwest corner of the Hyde Park subdivision, along what was then the edge of town. It was added to the National Register of Historic Places in 1990, though the designation does not guarantee its survival. (Author's collection.)

This undated image of the Capitol Hotel is a reminder to think carefully about the demolition of older hotels. Adaptive reuse and renovation could have saved such gems as the St. Elmo-tel, the Alamo Hotel, and the Villa Capri (see chapter four). (AHC AR2000.016 (173)/Larry Kolvoord.)

Austin's legendary moonlight towers used to number 31, but now stand at 17. The unique citywide street-lighting system was inaugurated in 1895. Instead of installing a system of regular light poles, the city accepted a proposal by the Fort Wayne Power Company, which used a system of 31 towers, each 165 feet high. Although some backyard farmers feared the bright lights would keep the chickens up all night, the towers quickly became a source of civic pride. While some towers have disappeared through neglect or development, the survivors are now closely watched by Austinites. (AHC C02047.)

Discover Thousands of Local History Books
Featuring Millions of Vintage Images

Arcadia Publishing, the leading local history publisher in the United States, is committed to making history accessible and meaningful through publishing books that celebrate and preserve the heritage of America's people and places.

Find more books like this at
www.arcadiapublishing.com

Search for your hometown history, your old stomping grounds, and even your favorite sports team.

Consistent with our mission to preserve history on a local level, this book was printed in South Carolina on American-made paper and manufactured entirely in the United States. Products carrying the accredited Forest Stewardship Council (FSC) label are printed on 100 percent FSC-certified paper.

MADE IN THE USA